RAINBOWS APPEAR

TIBETAN POEMS OF
SHABKAR

EDITED BY
MATTHIEU RICARD

CALLIGRAPHY BY
JIGME DOUSHE

SHAMBHALA
Boston & London
2002

SHAMBHALA PUBLICATIONS, INC.
Horticultural Hall
300 Massachusetts Avenue
Boston, Massachusetts 02115
www.shambhala.com

©2001 Albin Michel
Translation ©2002 Shambhala Publications, Inc.

Collection directed by Jean Mouttapa and Valérie Menanteau
Photography by Sylvie Durand
Layout Design by Céline Julien

9 8 7 6 5 4 3 2 1

First Shambhala Edition
Printed in France

⊚ This edition is printed on acid-free paper that meets the American
National Standards Institute Z39.48 Standard.

Distributed in the United States by Random House, Inc.,
and in Canada by Random House of Canada Ltd

LIBRARY OF CONGRESS CATALOGING-IN-PUBLICATION DATA

Zabs-dkar Tshogs-drug-ran-grol, 1781–1851.
 Rainbows appear: Tibetan poems of Shabkar/calligraphy by
Jigme Doushe; translated by Matthieu Ricard.
 p.cm. — (Shambhala Calligraphy)
 Uniform title in Tibetan not available.
 ISBN 1 57062-982-X
 1. Spiritual life—Buddhism. I. Title: Tibetan poems of Shabkar.
 II. Doushe, Jigme. III. Ricard, Matthieu. IV. Title.

BQ5650.Z328 2002
294.3'442—dc21 2002017008

Buddhism was established by the Buddha Shakyamuni in India in the sixth century BCE. It reached Tibet in the fifth century of our era, at the time when King Lhatori Nyentsen brought the first Buddhist texts back to the Land of Snows. However, it was not really until the reign of Songtsen Gampo, who passed away in 650 CE, that the teachings of the Buddha were implanted on Tibetan soil.

Shabkar was born in 1781 in Amdo, a province situated in the northeast of Tibet. From his earliest childhood, he showed a profound inclination toward the contemplative life. He went into retreat for the first time at the age of sixteen. In spite of his great affection for his mother and family, he resisted pressure from his relatives, who tried to persuade him to get married. He left his family home in order to devote himself entirely to the spiritual life.

His quest for sacred places led Shabkar to a small island called "Heart of the Lake," and then to other secluded hermitages, situated amid gorges, mountains, and glaciers. During his adventure-filled pilgrimages, he stayed in the very caves where Milarepa, of whom Shabkar was an incarnation, had lived.

After many years of wandering and privation, in the course of which the inspired hermit gave his teachings freely to all the beings he encountered—including bandits and wild animals—he was requested by his disciples to recount his contemplative experiences and his journeys through the Land of Snows. He fulfilled this request by producing a fascinating narrative that is punctuated with poetic songs. The poems in the present small volume are drawn from this autobiography, which I translated with Carisse Busquet for Albin Michel publications. These poems admirably reflect the wisdom of this peace-bringing yogi.

In a style that is both simple and elegant, and always eminently clear, Shabkar describes the various stages of his spiritual quest. His songs reveal to us the value and the meaning of human life, the significance of death and impermanence, the law of karma, and the suffering inherent in samsara, the cycle of rebirths. He extols the virtues of renunciation as well as the necessity of following a qualified master. He also puts forward an understanding of emptiness in which it is linked with infinite compassion. And finally, he teaches us of Buddha nature, innate in all beings. Shabkar propounds all these

truths and encourages us to keep living them in a real way—until the point is reached when they become an integral part of us.

His entire art consists in interpreting the phenomenal world as a guide to contemplative life. Thus he sees his spiritual masters seated, magnificent and resplendent, on the peaks of majestic mountains or in the immaculate clouds. A luminous and transparent sky strengthens his comprehension and knowledge of the Great Perfection. Changes brought on by the seasons—the withering of flowers—are bearers of melancholy and evoke impermanence and death. The murmuring of mountain streams, the rustling of the wind, and the singing of birds are so many reminders of the teachings of Buddha and of his conversations with his spiritual masters and friends.

Shabkar passed away in 1851. One day at the hermitage of Tashi Khyil in Amdo, as my master Dilgo Khyentse Rinpoche was sitting in the shade of a tree where Shabkar used to come to sing, a rain of flowers fell. Many people saw in this flowery downpour a sign that the celebrated "bard of the Land of Snows" had been reincarnated.

Matthieu Ricard

A Wonder!

Behind me, the rock walls,
Beautiful and massive.
In front, snow on the peaks
Of the majestic range.
In the four directions, the mist rises,
And rainbows appear.

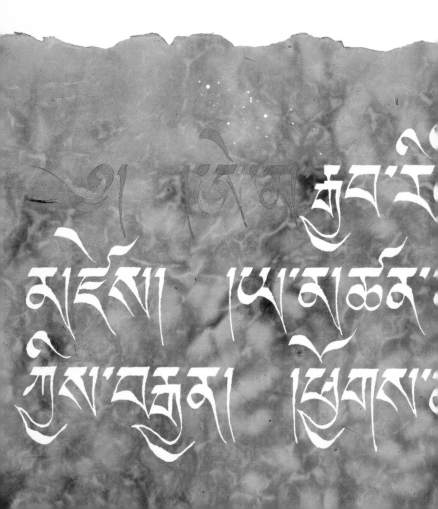

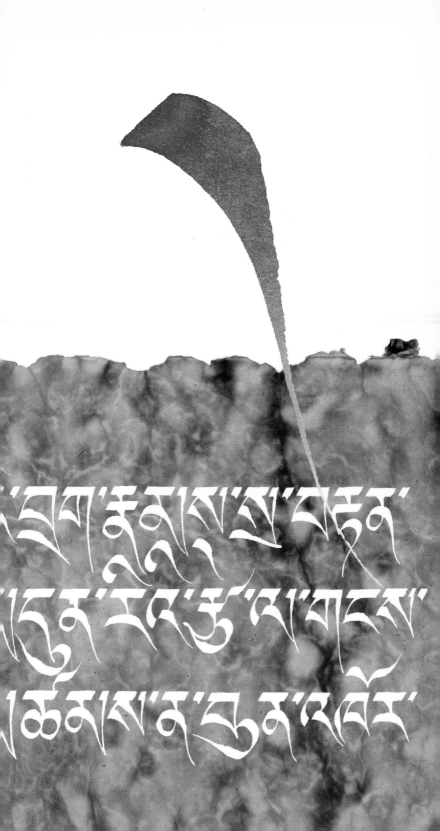

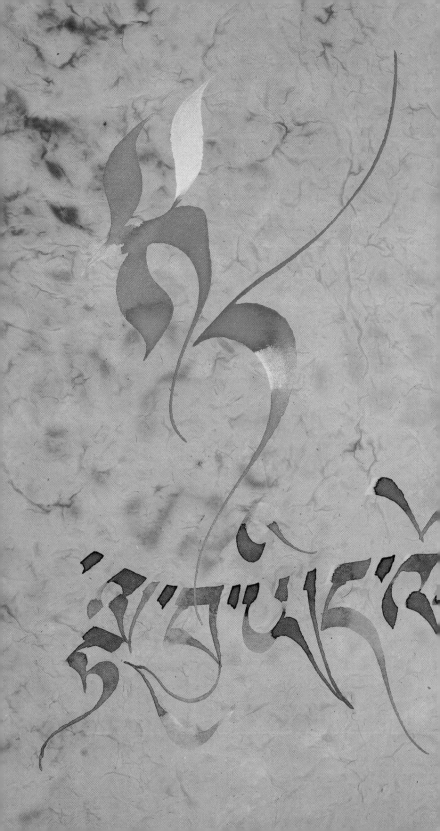

The divine bird,
 the ptarmigan, beautiful partridge of the snows,
Has sought out the grass of the plains
 and the water of the falls.
Now he keeps
 to the edges of the eternal snows;
In the mist of the summits
 his **musical call** resounds.

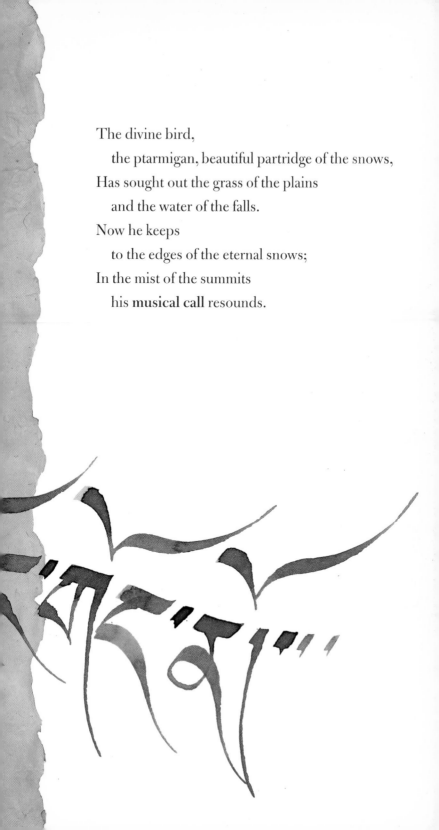

Just as the **flight** of a bird
in the clear sky
Leaves no wake behind it,
For the yogi, thoughts
are the absolute nature;
And he is fully content.

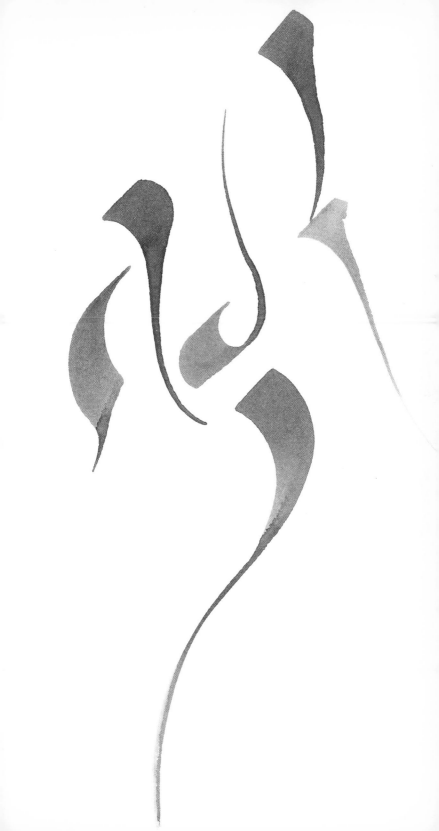

Looking at the thousands of wild
 yaks and wild asses
Wandering on the vast plain,
The pretense of the nomads
 to possessing large herds,
Is nothing but vain **boastfulness.**

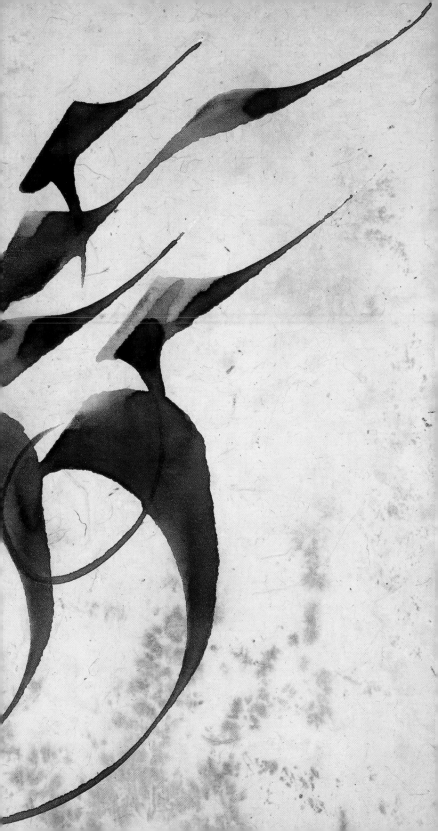

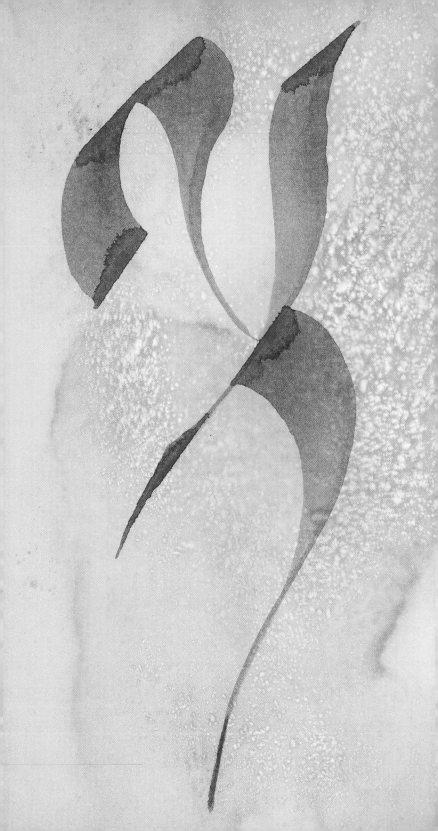

If there is a preconception, there is no **view**,
If there is attachment
 to things seen as real,
 there is no authentic meditation.
If there is preferring and rejecting,
 there is no right action.

The tall house of beaten earth
 is the view.
Its solid foundations
 are **meditation**.
The walls, painstakingly heaped up,
 are action.
These three elements together form
 the house of beaten earth
 that lasts forever.

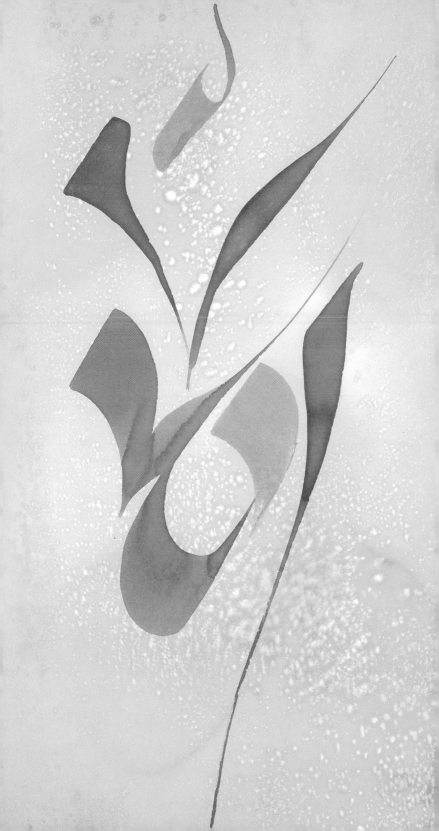

If one would cultivate a view
 higher than the sky,
Then attention to **deeds**
 and their consequences
Must be of finer grain still
 than barley flour.

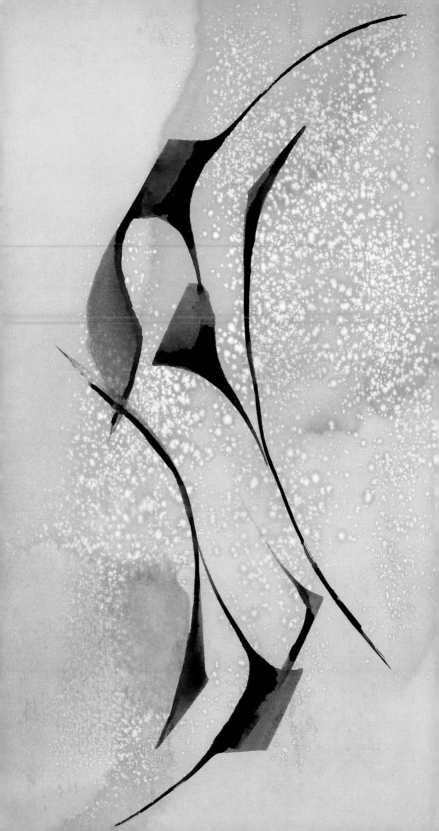

If you cannot bear
the least disagreeable remark
Do not pretend to **patience.**

If you cannot sit still
if only for the length of time
it takes to drink a cup of tea,
Do not pretend to **concentration**.

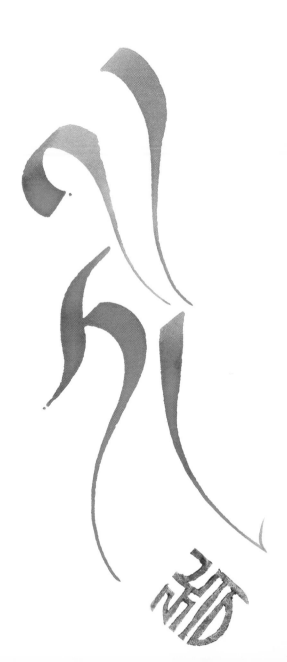

Keep your body still;
Keep silent;
Do not restrain your thoughts, let them come;
Let consciousness relax
Into a perfect state of **ease**.

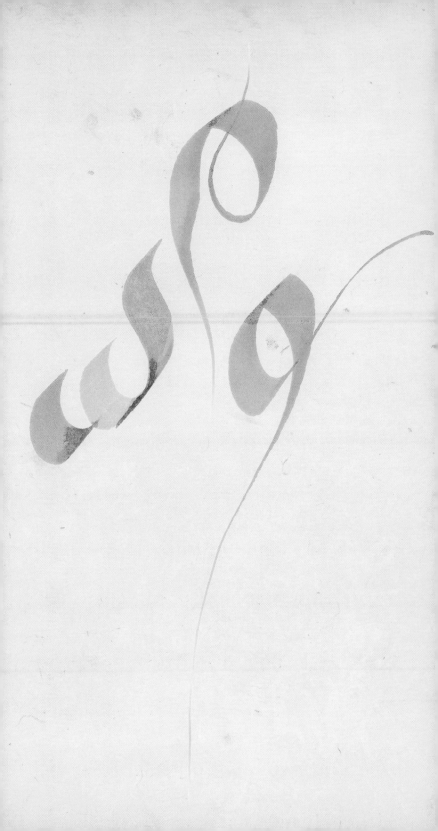

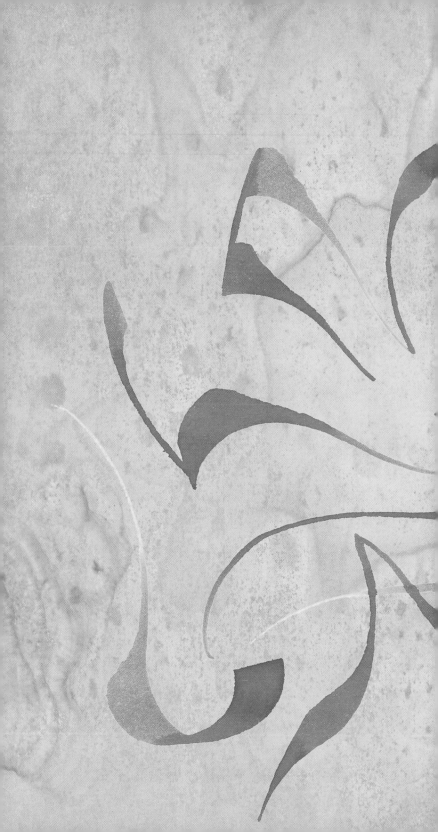

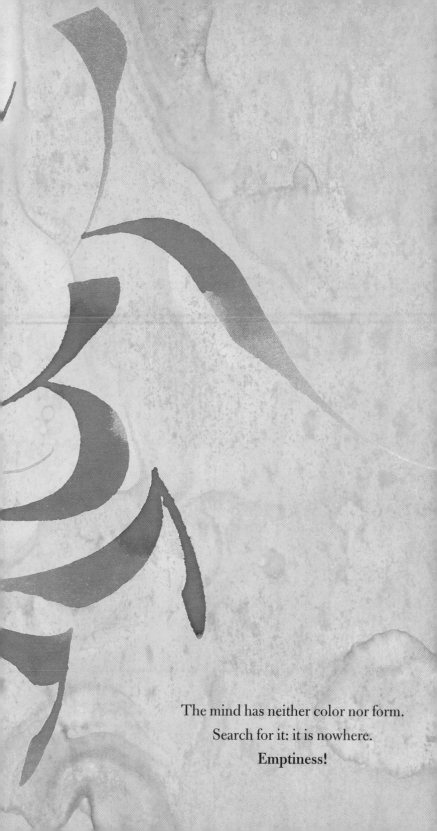

The mind has neither color nor form.
Search for it: it is nowhere.
Emptiness!

One must remain in the **vastness**,
 alert and lucid,
Letting one's gaze encompass
 the infinity of the sky,
As though seated on the summit
 of a mountain open
 to all the horizons.

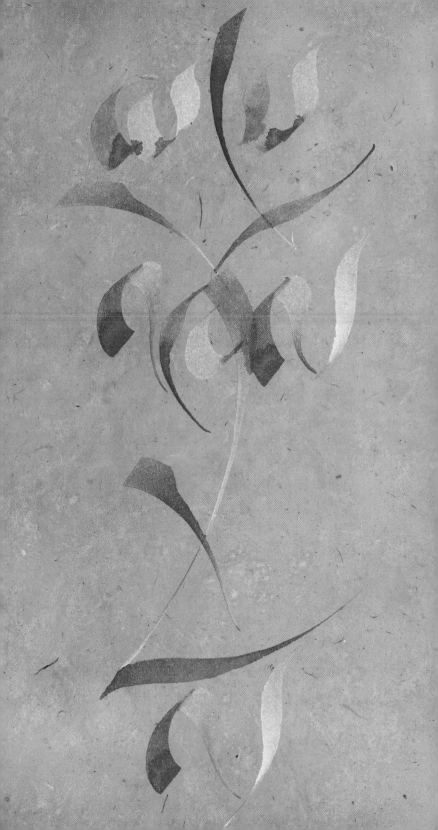

The **moon** rises
 in the pure sky of night,
Its reflection appears
 on the still surface of the lake.
But the moon is not in the lake,
 isn't that right?
Know that it is thus with all phenomena.

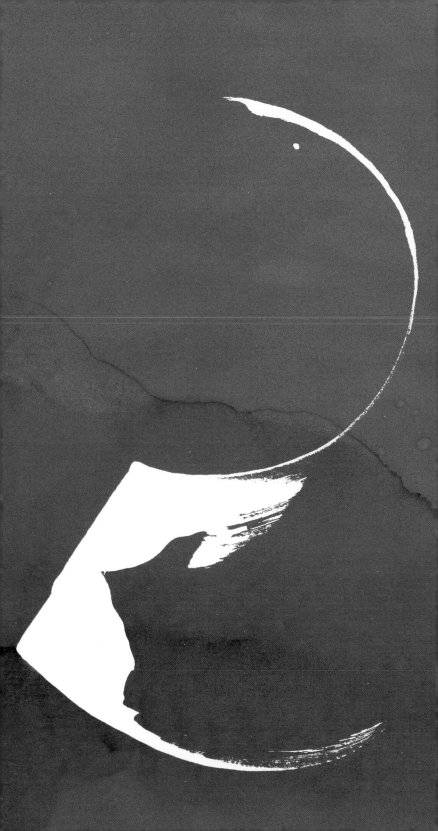

Incense, flowers, and lamps are not
The best offerings to the Buddha.
The most beautiful **gift** to the Buddha
Is good done for beings.

Hurting others
 amounts to hurting oneself;
Helping others amounts to helping oneself.
Displaying the faults of others
 amounts to exhibiting our own.
Stressing their **good qualities**
 amounts to revealing our own.

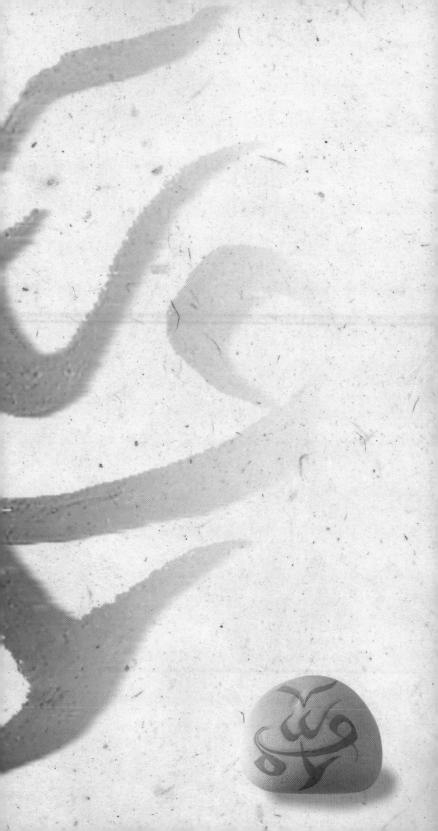

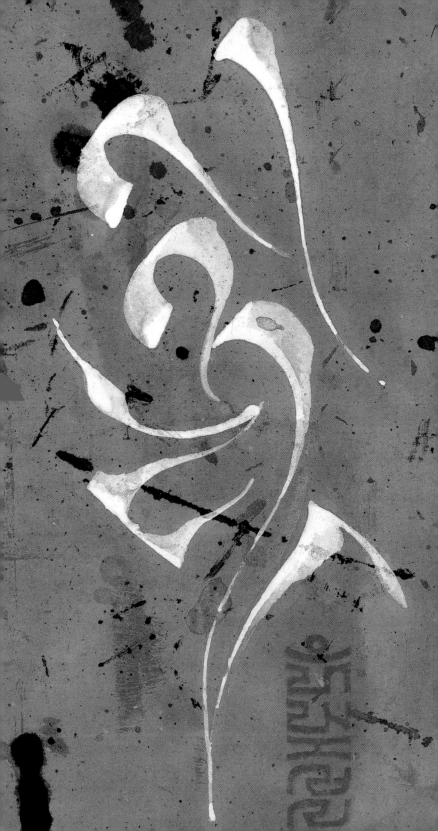

Your prime goal
 must always be
To generate and nurture
 in your heart a love
That is such that the pain of others
 is unbearable to you.
Carry on like this until the birth
Of true **compassion,**
 natural and spontaneous.

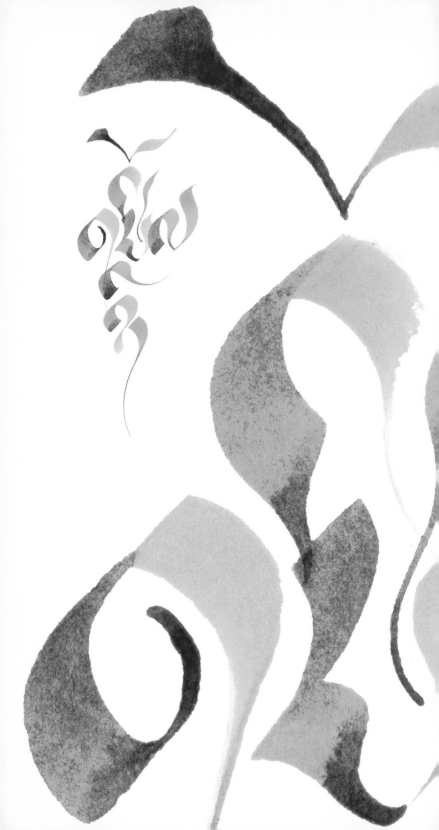

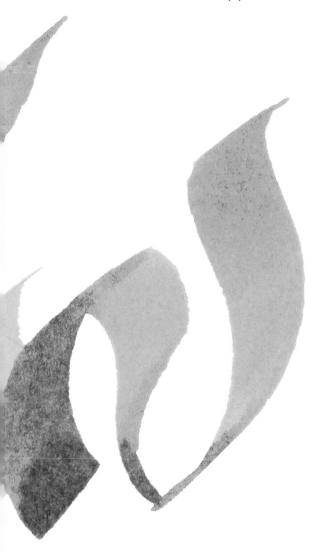

In the vastness of the sky,
 without center or edges,
The **sun** shines, illuminating
 all things without choosing.
This is the way you should help beings.

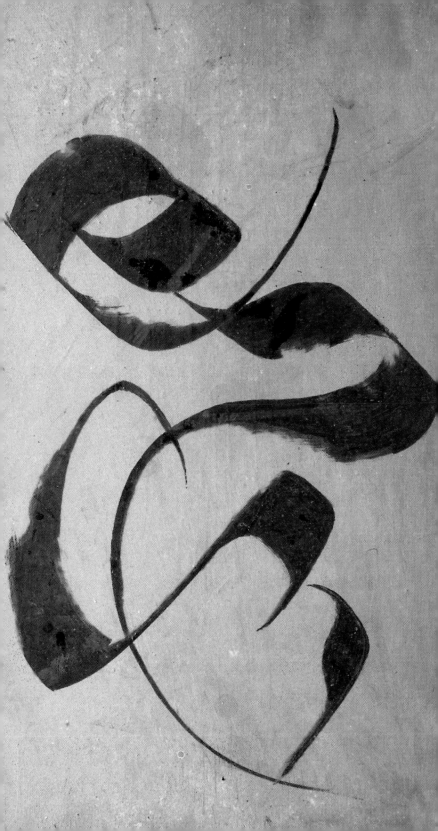

Though we have provisions
 for a hundred or a thousand years,
On the threshold of **death**
 we will have to abandon them all.
Though we have a wardrobe sufficient
 to clothe us for a hundred or a thousand years,
On the threshold of death, we will be naked.
Though we have in our possession
 a hundred or a thousand pieces of gold or silver,
On the threshold of death,
 our hands will be empty.
Though we may be surrounded by a hundred
 or a thousand relatives and friends,
On the threshold of death, we will be alone.
That is the way it is!

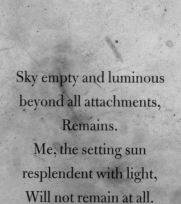

Sky empty and luminous
beyond all attachments,
Remains.
Me, the setting sun
resplendent with light,
Will not remain at all.

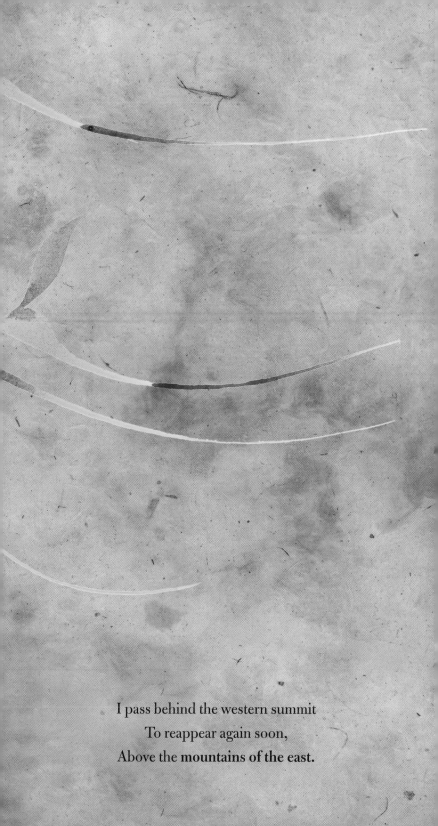

I pass behind the western summit
To reappear again soon,
Above the **mountains of the east.**

The cat seems to be
 deeply asleep
But has still not forgotten the mice.
The renunciate can live
 on far distant mountainsides
And still not **forget** food and clothing.

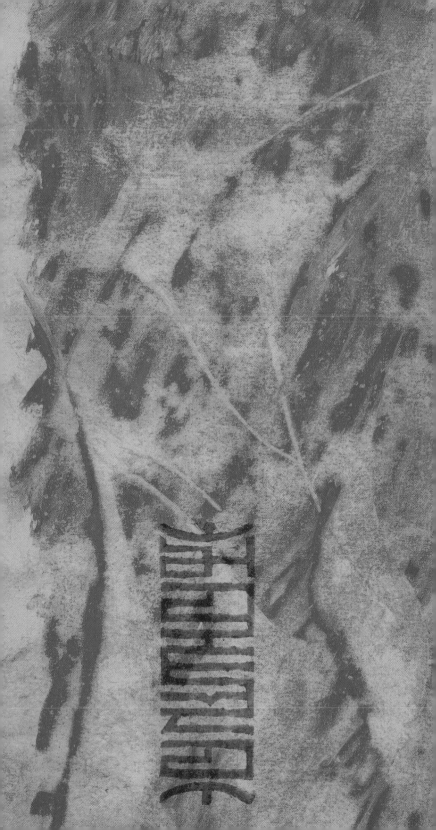

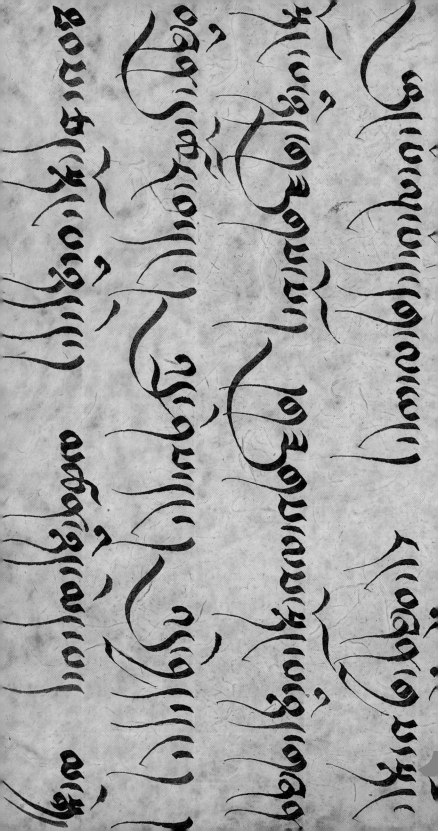

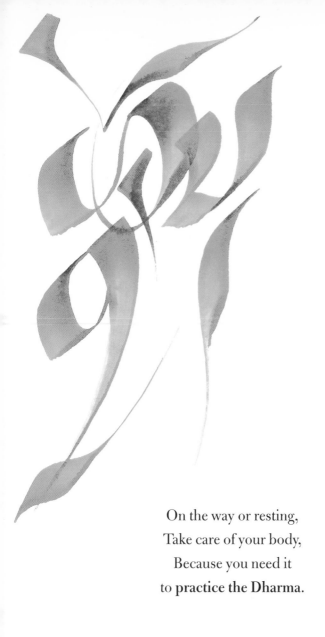

On the way or resting,
Take care of your body,
Because you need it
to **practice the Dharma.**

Once torpor, stupor, and sleepiness
Have been **swept away**,
The natural state of the mind will appear:
Clear, empty, naked,
Immaculate like the sky of autumn.

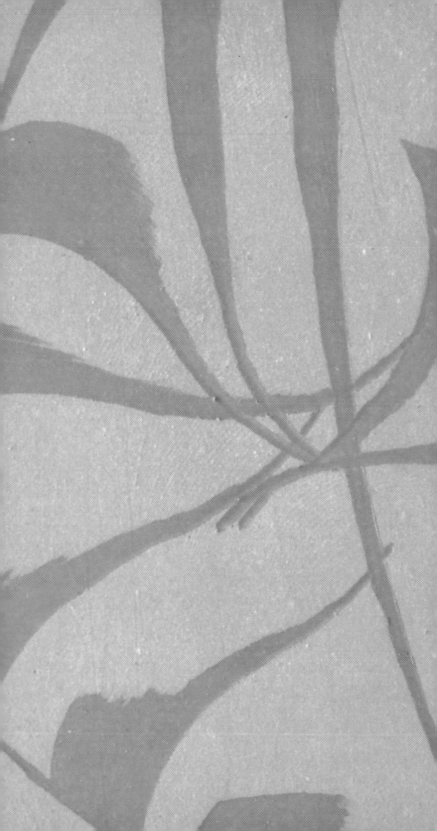

Kindness and openness of mind
Will **accomplish** all goals:
Yours and those of others.

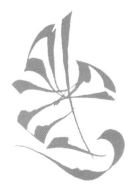

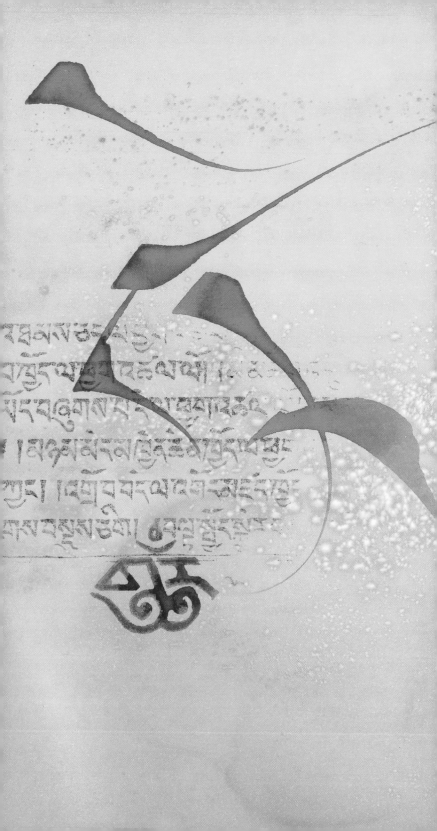

ཅཀལཾ་ཡོཙོངོལཅཀུ།
ཝཅུདཔཡོངོ་ཅཚལཁ། ༑
པ་ཌལདུགོནཔ་ས་ཅ་པ་གཌཅ
༑ ཝཀ་ཁན་ན་ཅ་ཅེ་ཝཙོ་ཀ་པཟ
ཅུཾ །ཝཀྱོ་ཝ་ཅ་ཡཅོ་ཙེ་ཙཆཙོ་ཅ
ཁཔ་ཝསུས་ཅེ། ༑ཝཀྱོ་ཙོ་ཙས་ས།

In the beginning I took my master for my master,
In the middle, I took the scriptures for my master,
In the end, I took my **mind** as my master.

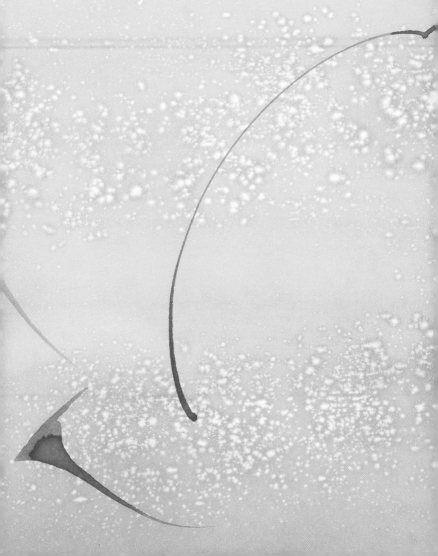

See how, shaped by the excellence of the path,
I walk now without effort
toward the Buddha state.
I dance, I sing, I play!

JIGME DOUSHE

IT IS GENERALLY AGREED that Buddhism was introduced into Tibet in the seventh century of our era, at the same time as the Tibetan script was invented. These two major events took place in the reign of the first great king, Songtsen Gampo. The ruler sent one of his ministers, Thonmi Sambhota, to Kashmir, to study Sanskrit grammar and the various Indian scripts. By this time, Tibetan civilization had significantly expanded and taken on both political and geographical importance. Tibet was a vast kingdom extending from Baltistan to Chang'an, the capital of China, and as far as Magadha in the north of India. It was subject to a variety of influences, all of which played a role in the defini-

tive form taken by its script. The structure, the skeleton of the Tibetan script, comes from India; its flesh, which derives from the use of the calamus, the reed pen, comes from Persia and Turkestan; finally the brushlike effect, which is quite unique to Tibetan characters, with nuances resulting from the pivoting of the writing instrument, comes from Tang China. However, the Tibetans were not really a people without a means of writing. Starting with proto-Tibetan, the Gupta, two styles emerged, one from Shangshung (the name of ancient Tibet) and the other from Indian Kashmir. The Tibetans elaborated these into an original alphabet composed of thirty consonants and four vowels, with the writing going from left to right.

Closely linked early on with the administrative and diplomatic activities of Tibet, the script was later put in the service of religion. Starting in the eighth century, Indian and Tibetan scholars joined together in the immense task of translating the huge number of texts constituting Sanskrit Buddhist literature. This labor was of great complexity, for the vocabulary needed for translating the numerous terms unique to Buddhism was lacking in the Tibetan language. Methodically, the scholars invented an entire terminology, which permited them to compile a remarkable Sanskrit-Tibetan dictionary.

After the collapse of the Tibetan empire in 842, the most significant effort to revitalize Buddhism in Tibet

came from one of the most famous of Tibetan translators, Rinchen Zangpo. I feel a close affinity with this monk who contributed to the positive development of calligraphic writing and the Tibetan arts by translating the sutras (the words of Buddha) and the tantras (ritual treatises). *bZangpo*, in Tibetan, means "good" or "beautiful." The characters that compose this term are connected with three words that are key terms for calligraphers: *bLa*, the first syllable in lama, which means "the best"; *gZab*, "elegance"; and *Ngobo*, "nature" or "character." Offer the best, provide elegance, respect the nature of the meaning—that is the basic calligraphic program I tried to follow in presenting the thought of Shabkar through four styles of writing: U Chen or the elegant; Dutsa, or the extended; Kyu Yik, or the cursive; Hor Yik, or the sigillary script, used for seals.

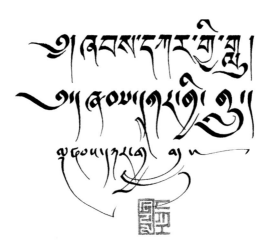

The development of U Chen stabilized in the seventh century, and the script was definitively formatted for

printing around the twelfth or thirteenth centuries. U Chen was the script used to transcribe the sacred texts. It is a slow form of writing, very formal. It is quite demanding and used very little by Tibetans these days. Dutsa, the calligraphic style of government and administration is presently the most commonly used. Originating with the culture of Bön (the indigenous religion linked with Tibetan royalty), it was superbly developed by the secular and religious administration. The cursive, Kyu Yik, is the script used in letter writing. Its fine lines reveal movement and personality. As for the vertical sigillary script, it dates from the thirteenth century and was created by the emperor Kublai Khan, who counted Marco Polo among his followers, to transcribe simultaneously Mongolian, Tibetan, and Chinese. Nowadays it is only used to create seals and ornament the entrances of temples. In the present little book we have the seals for snow lion, for skillful means, and for "White Imprint," the literal translation of Shabkar.

Faithful to Tibetan history in my choice of scripts, I also respected tradition in my choice of calligraphic media and used Tibetan paper. This paper comes from the bark of the laurel, a bush that grows in the foothills of the Himalayas. The pulp it yields makes the paper very absorbant, therefore it has to be sized with cereal starch. Once this operation has been completed, the paper is next tinted with tea or indigo. A second traditional technique that uses ash is used twice here to express the concepts of death and accomplishment (indicated by bold-

face in the texts). The principle consists in taking a base material such as wood and blackening it. The material is greased with yak butter and then ash is strewn on top of that. The lines are then drawn without ink.

The presence of stones in some of my compositions is a further expression of my wish to highlight the basic elements of Tibetan culture. For on the roads in the Himalayas in the neighborhood of villages, stones carved with sacred formulas and cairns of stones remind the inhabitants of the precepts of Buddhism. I put a series of three small stones, which symbolize body, speech, and mind, together with the three calligraphies interpreting the concepts of view, meditation, and action.

By no means less important, the colors used in the calligraphies are part of the Tibetan palette: gold signifies quality; orange, knowledge; blue, method; and the dark brown of the traditional ink recalls the tents of the nomads.

The word "to write" in Tibetan, covers at once the making of lines or strokes, drawing, and calligraphy. *Yik zuk*—the form, the presence of the sign—defines calligraphy, which is done with an instrument called a *nyugu*, a small piece of bamboo, cut and formed with a large nib. Its breadth and edge make it possible to execute three basic movements: moving, pivoting, and joining. According to the Tibetans, letters should not be beautiful, as the Greek etymol-

ogy of the word would suggest, but precise and well-formed. This approach to signs and characters is connected with the notion of their composition in space. Balance, the harmony of the calligraphic work, depends on the relationship between form and "non-form." In the Heart Sutra (of which I presented a few lines to accompany the poem on the Dharma), Buddha teaches that "form is empty, and emptiness is form." Thus when the calligrapher makes a stroke, he is primarily delimiting space, and in entering into this space, he imbues the stroke with life. The Buddhist concept of emptiness translates the thought that a thing never exists by itself, but always in its relationship to something else. The human being is at the same time inside and outside, without there being an opposition between the two. He is at the same time in the heart of his act and in the contemplation of what he is producing. In the same way as a letter is composed of black and white, the human being is in the center and at the edge of the world.

"If you toss a dream into the air, half of it falls on your head and the other half on your neighbor's head." "When you smile at life, half of it is for your face, the other half for somebody else's." Different variants of this Tibetan maxim all illustrate the value connected with the idea of relationship. The same theme is present in the beginning of the Tibetan alphabet, where we find the famous *svasti*—happiness in Sanskrit—which serves

as the heading to every text. Here I have articulated it into three parts: the base, representing the root of the lotus; the center, its spreading out; the little drop, its essence. This *svasti* signifies being at ease so one can do one's work, but it also invites the person who is preparing to read to enter into this state of ease. The foundations of calligraphy—relation, model, and breath—are connected with the three bodhisattvas who are the protectors of Tibet. They are incarnations of knowledge, compassion, and energy.

There is a maxim that comes from *dzogchen* (Great Completion)—a philosophy that is both Bön and Buddhist—that I like to pass along. It brings together in several verses all the letters of the alphabet, which itself is a symbol of the universe and its resonances: "Two nostrils to breathe with, two eyes to see with, two hands to do calligraphy with, and form and emptiness to understand with." The two nostrils correspond to yogic breathing, inhalation and exhalation. The two eyes represent the inner view and the outer view. The two hands are the